HARE COLORING BOOK

CRYSTAL
COLORING BOOKS

Copyright © 2019 Crystal Coloring Books
All rights reserved.

ISBN: 9781700209856

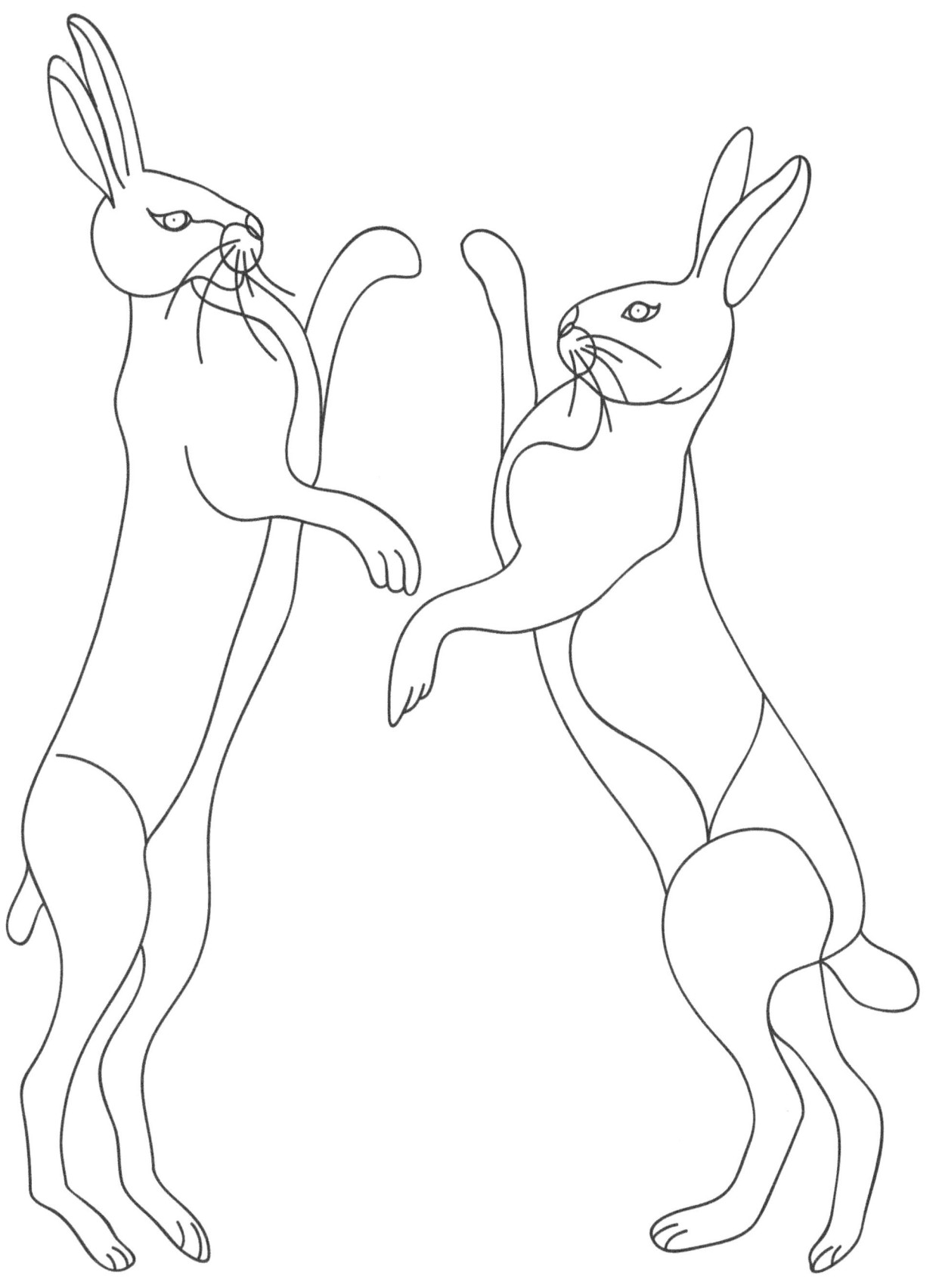

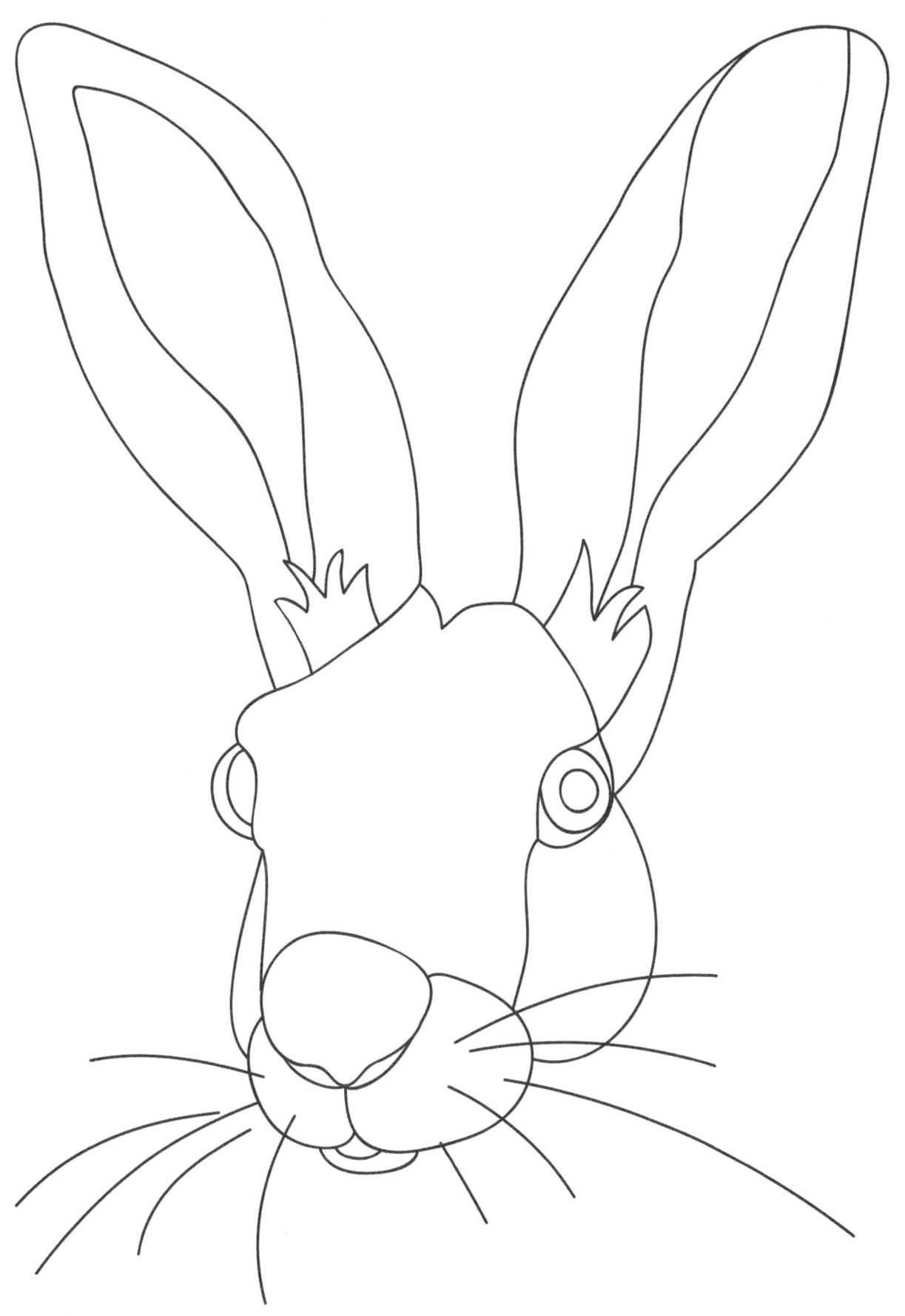

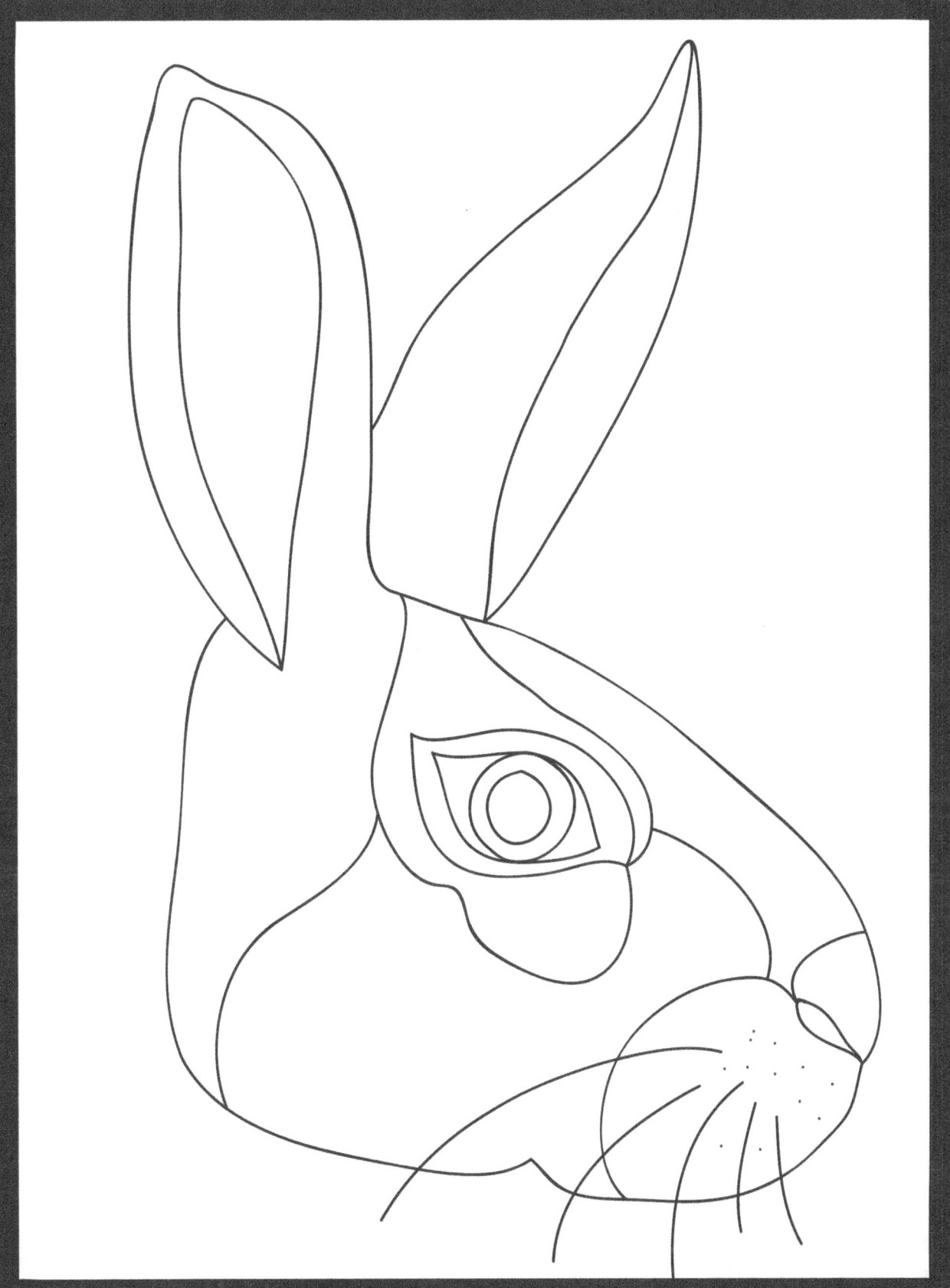

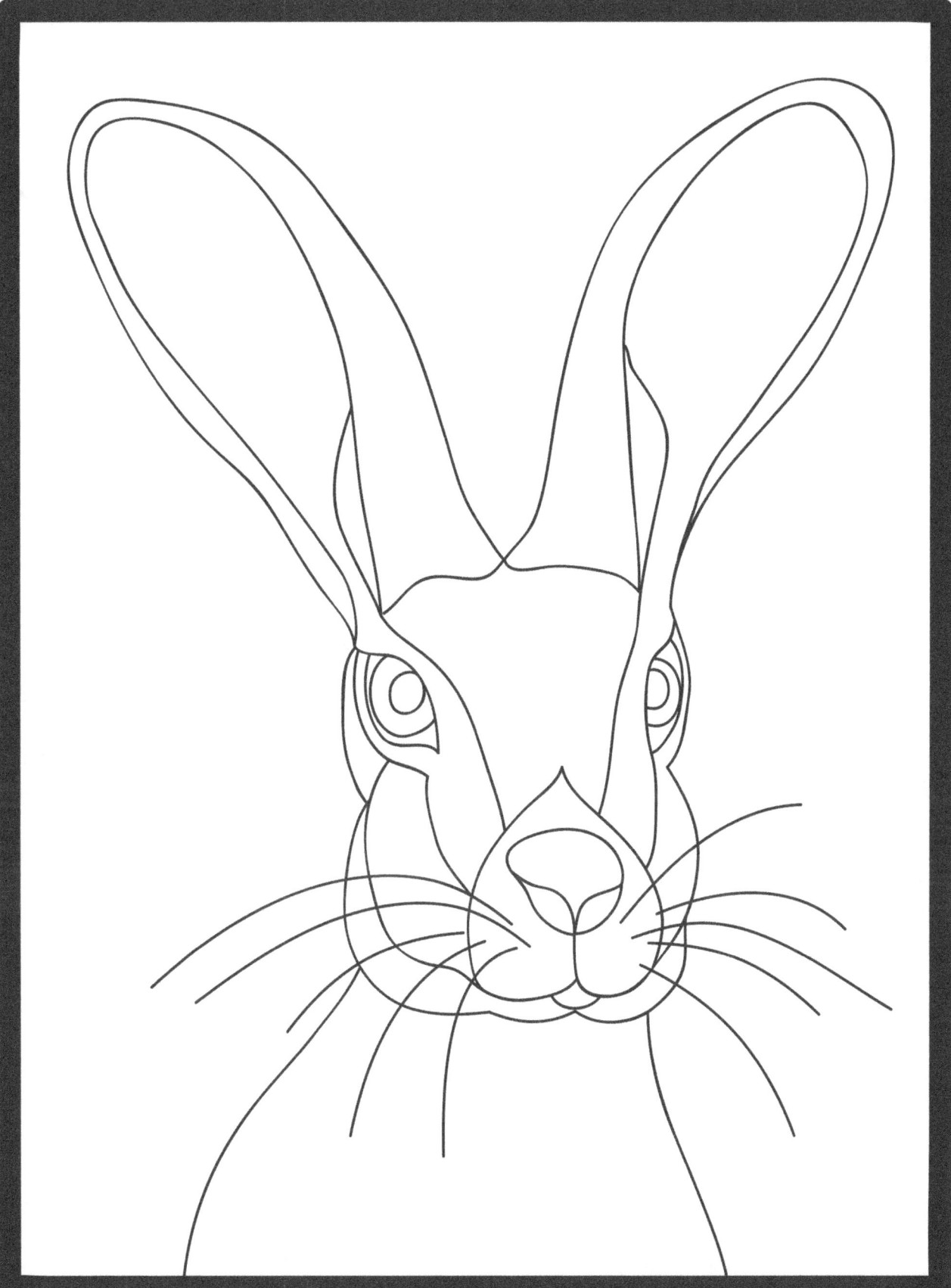

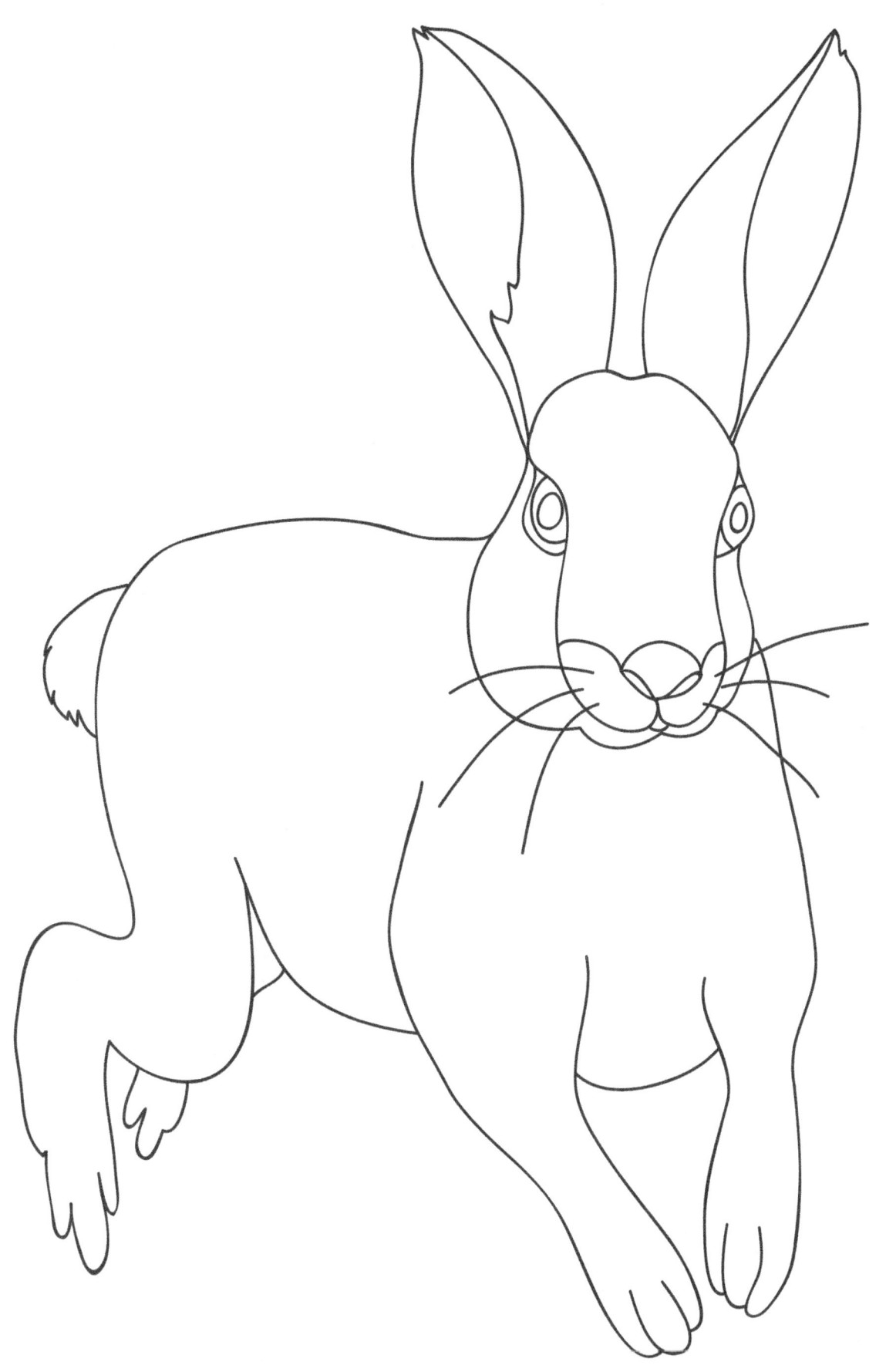

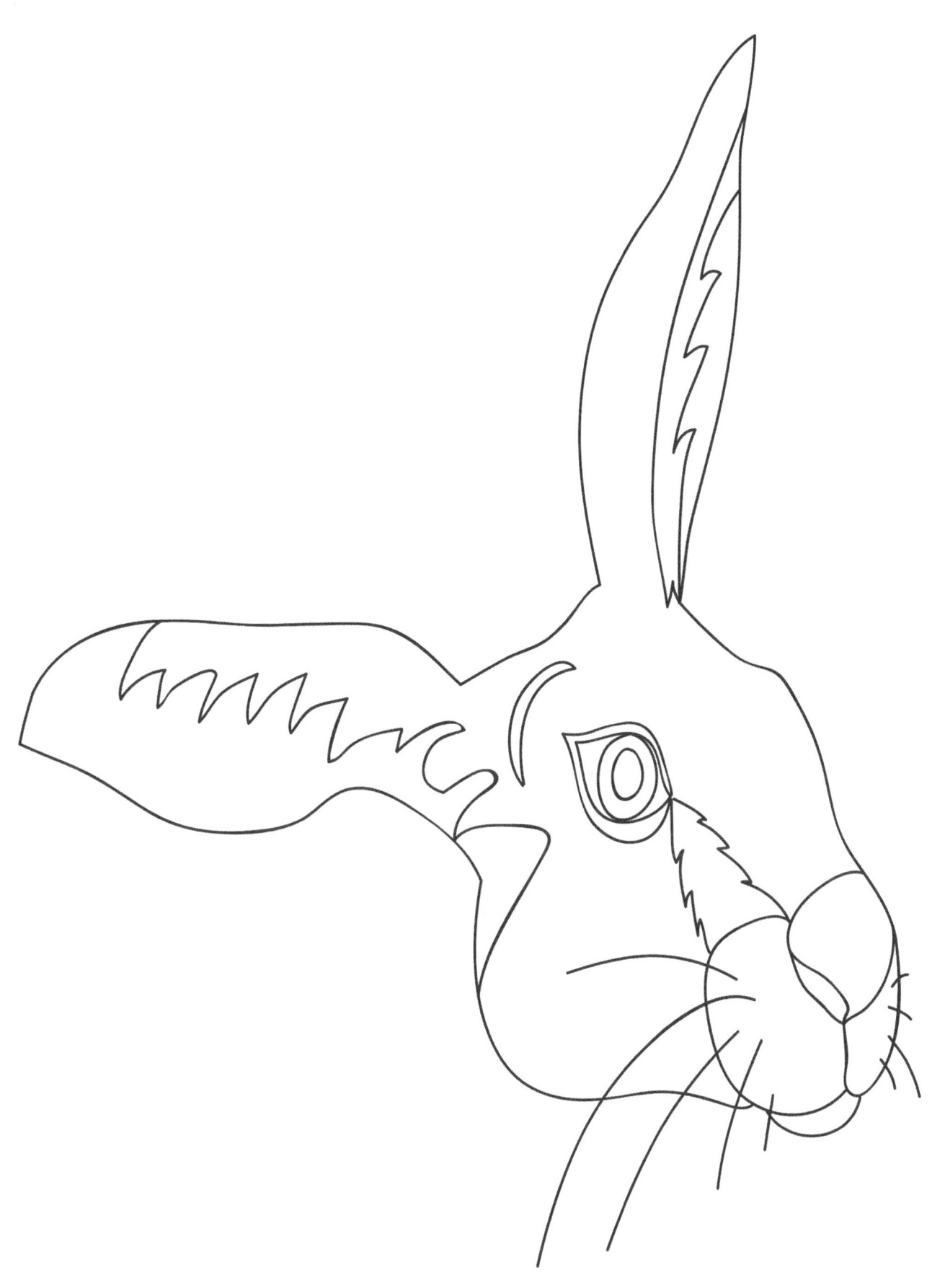

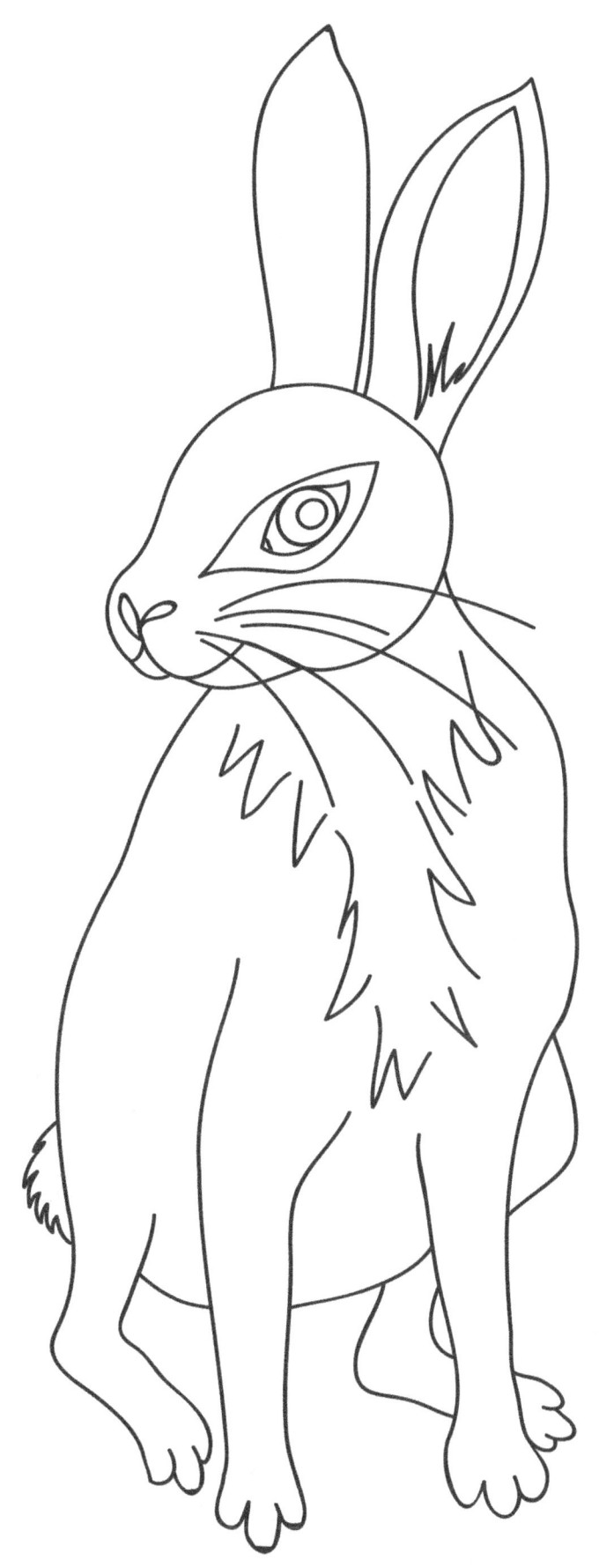

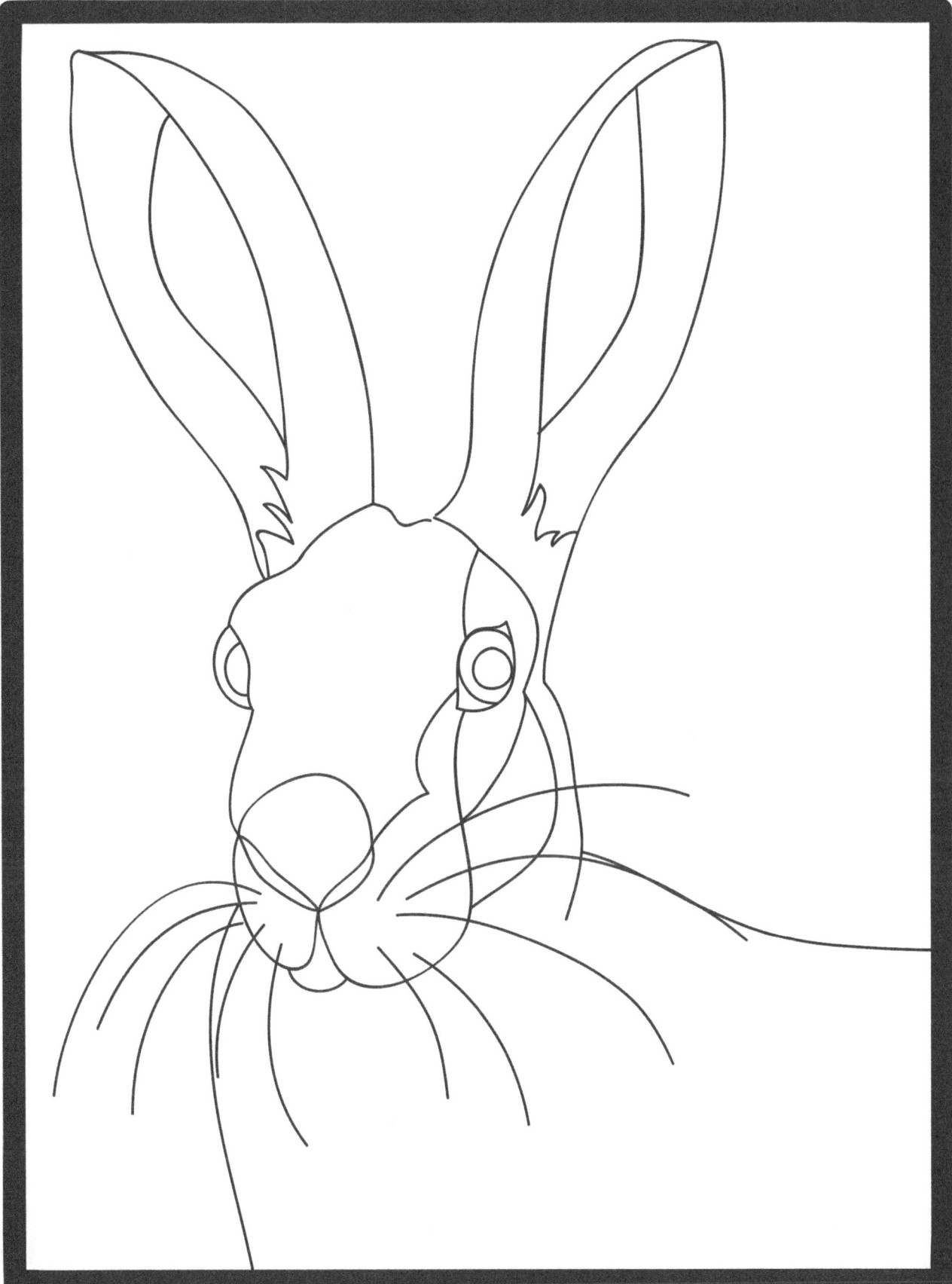

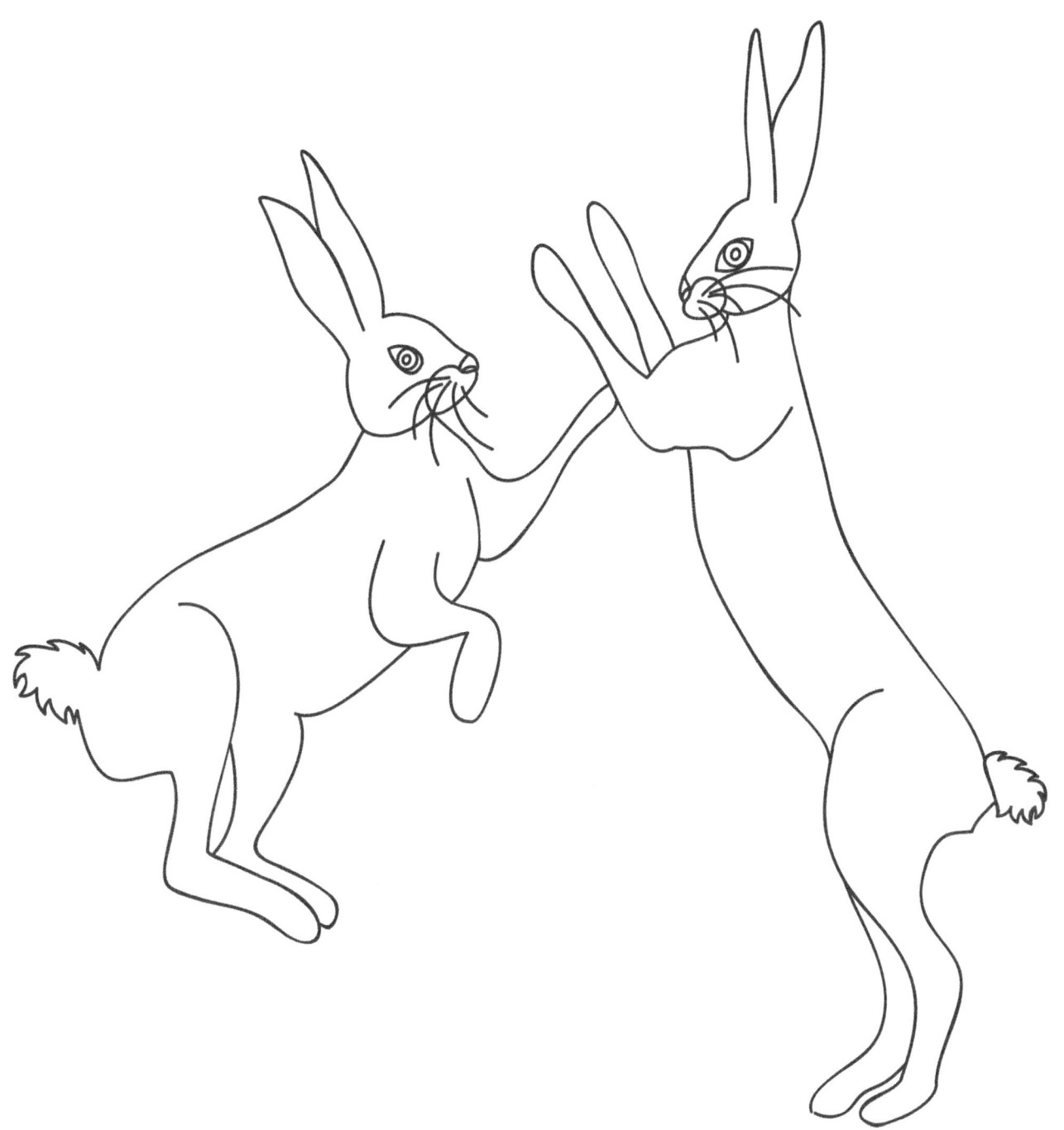

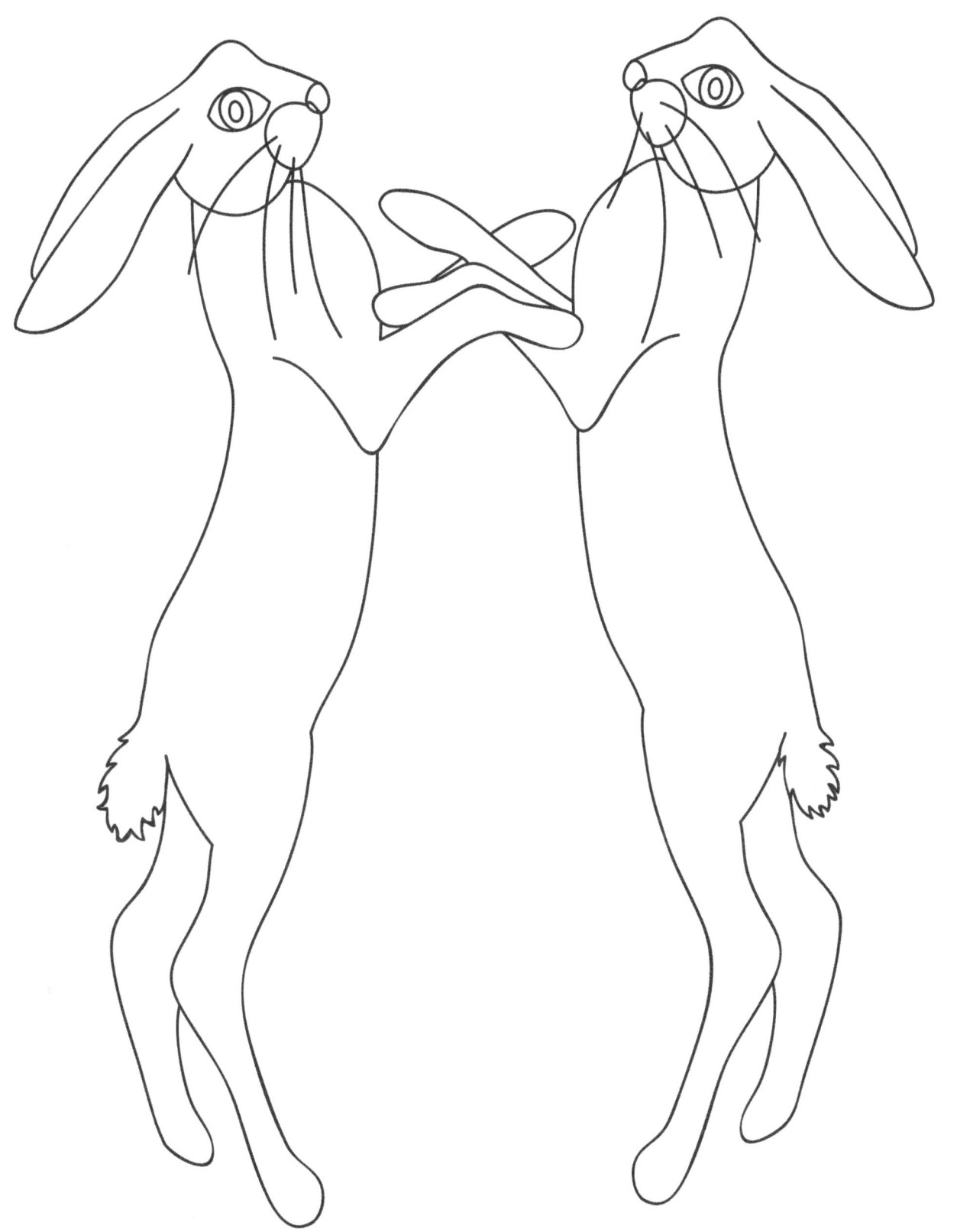

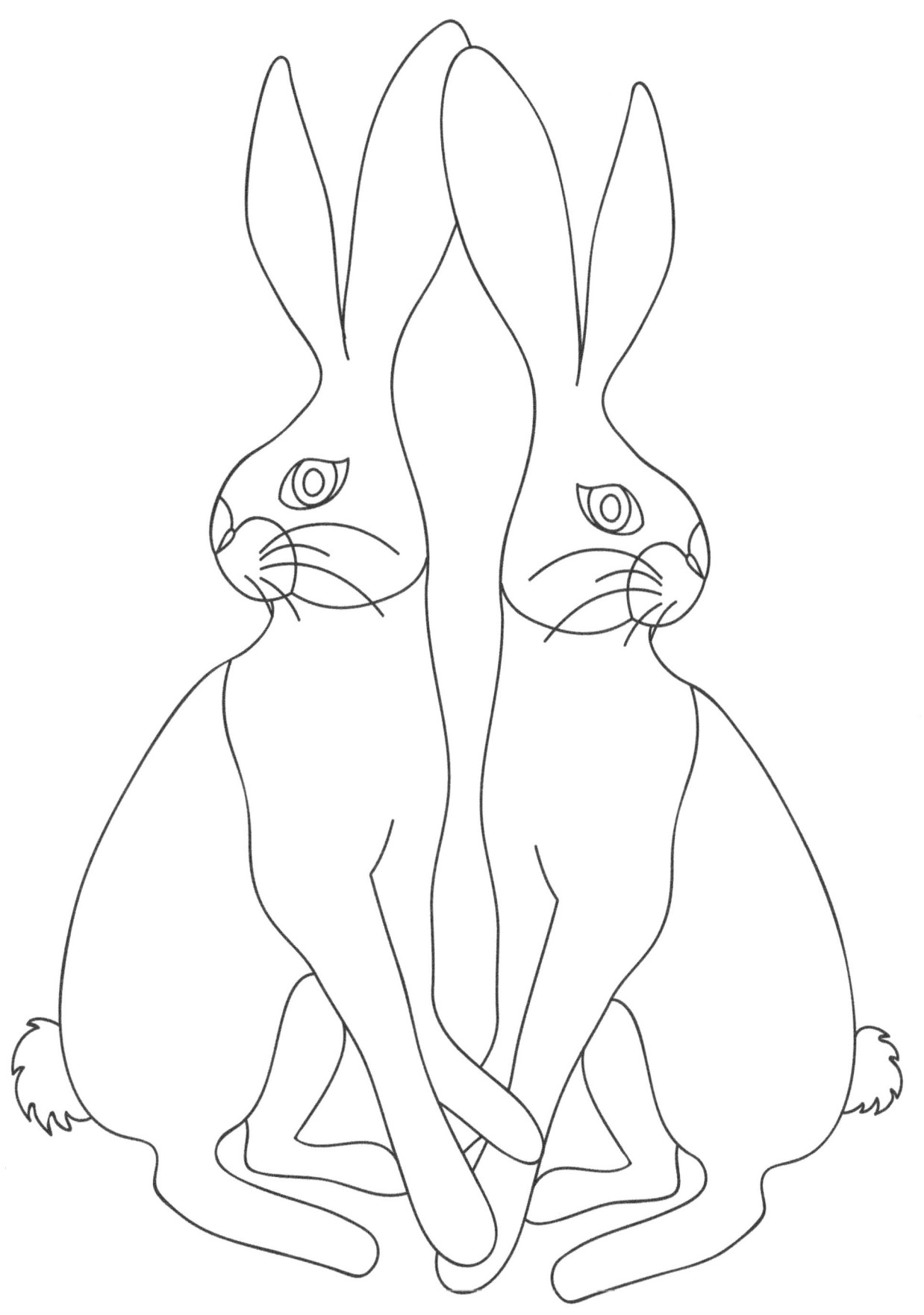

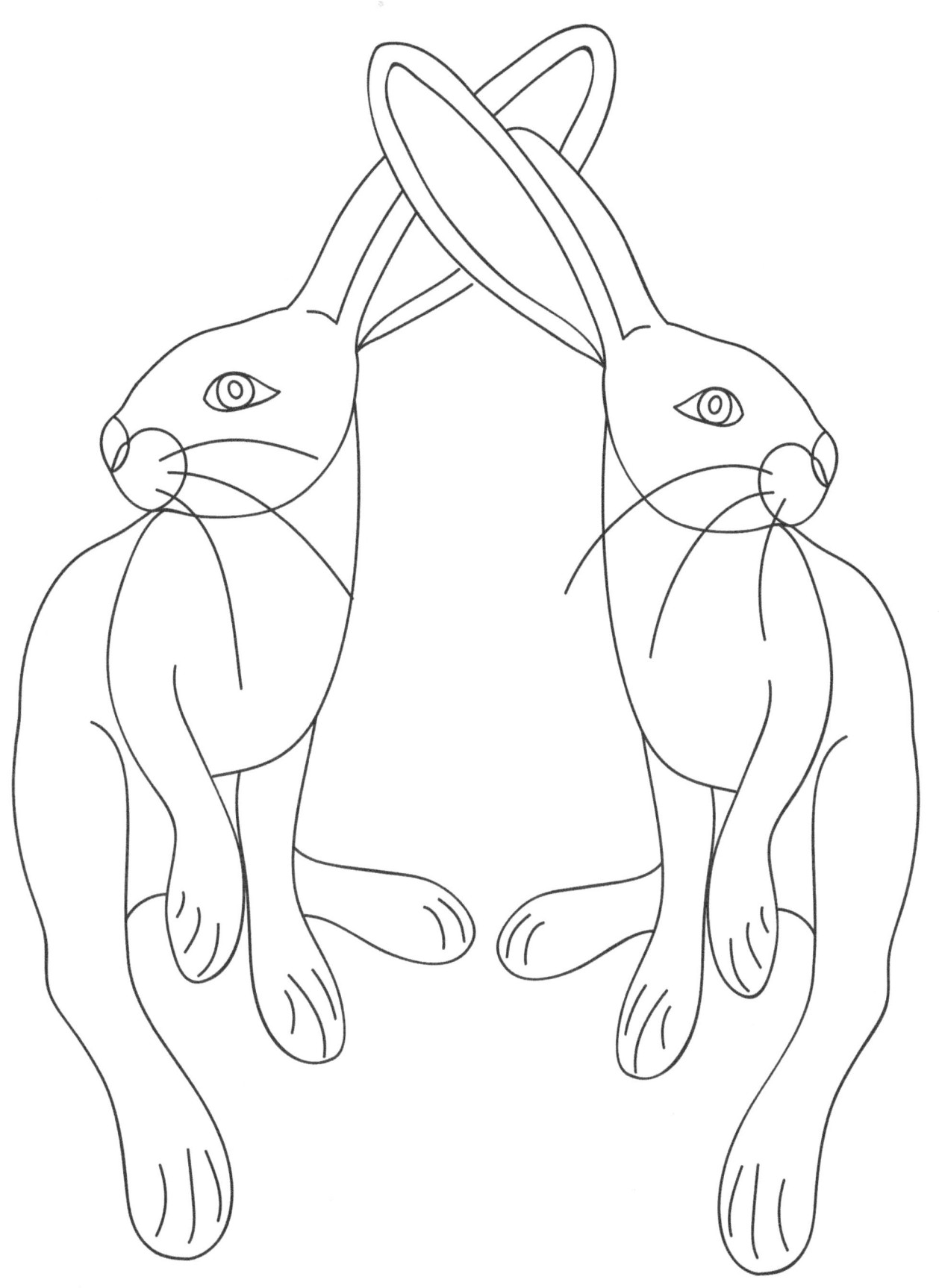

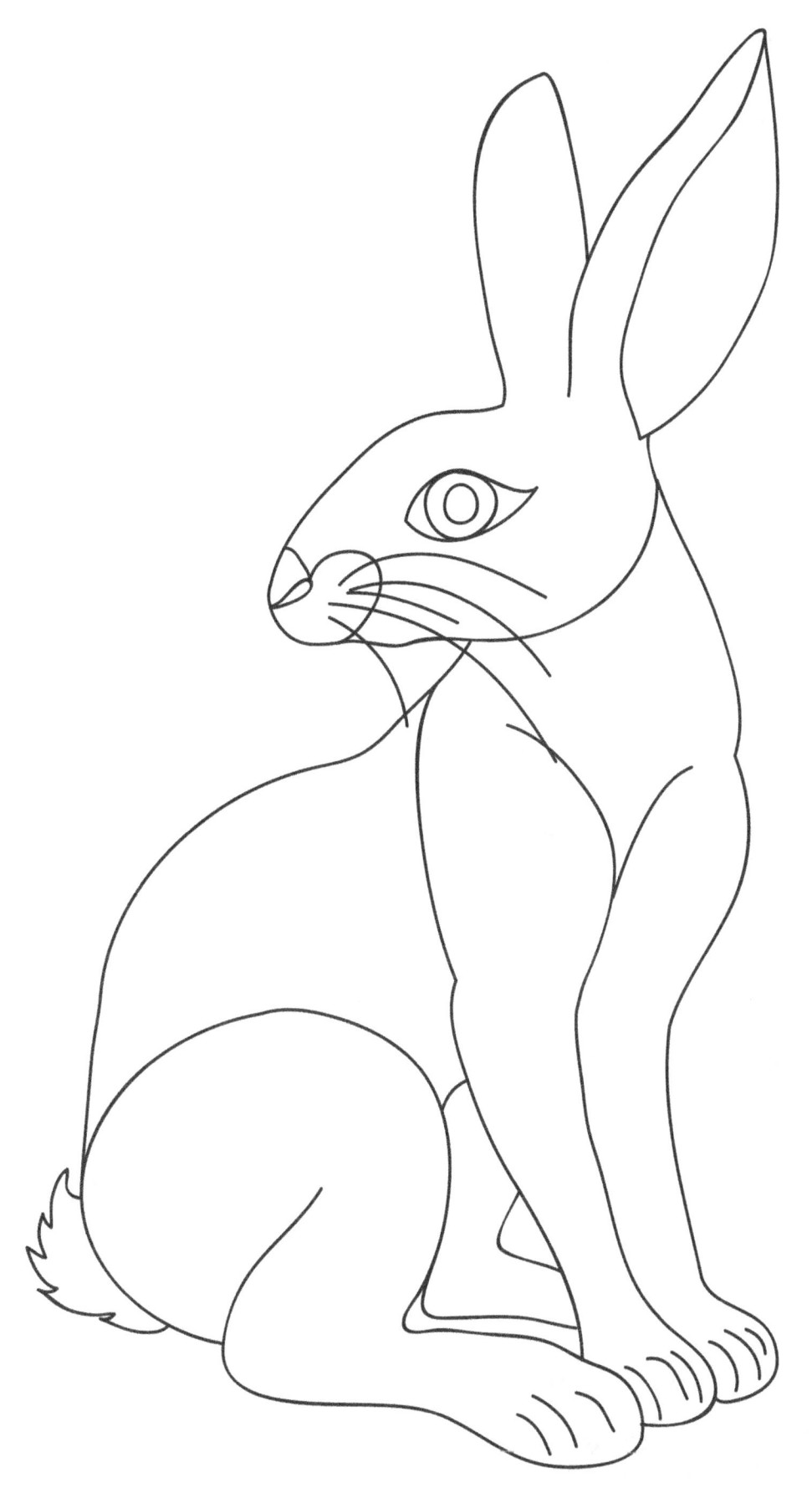

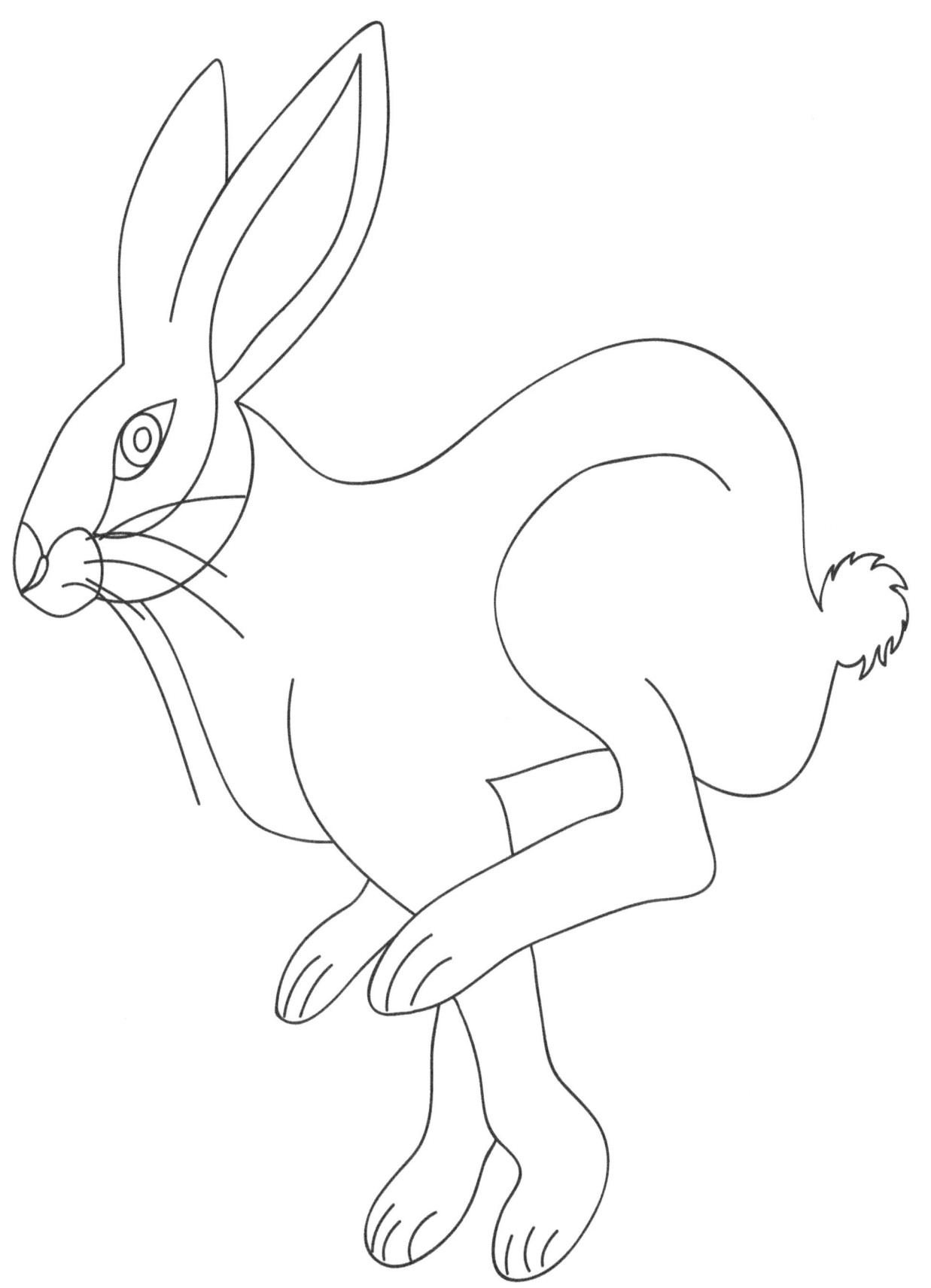

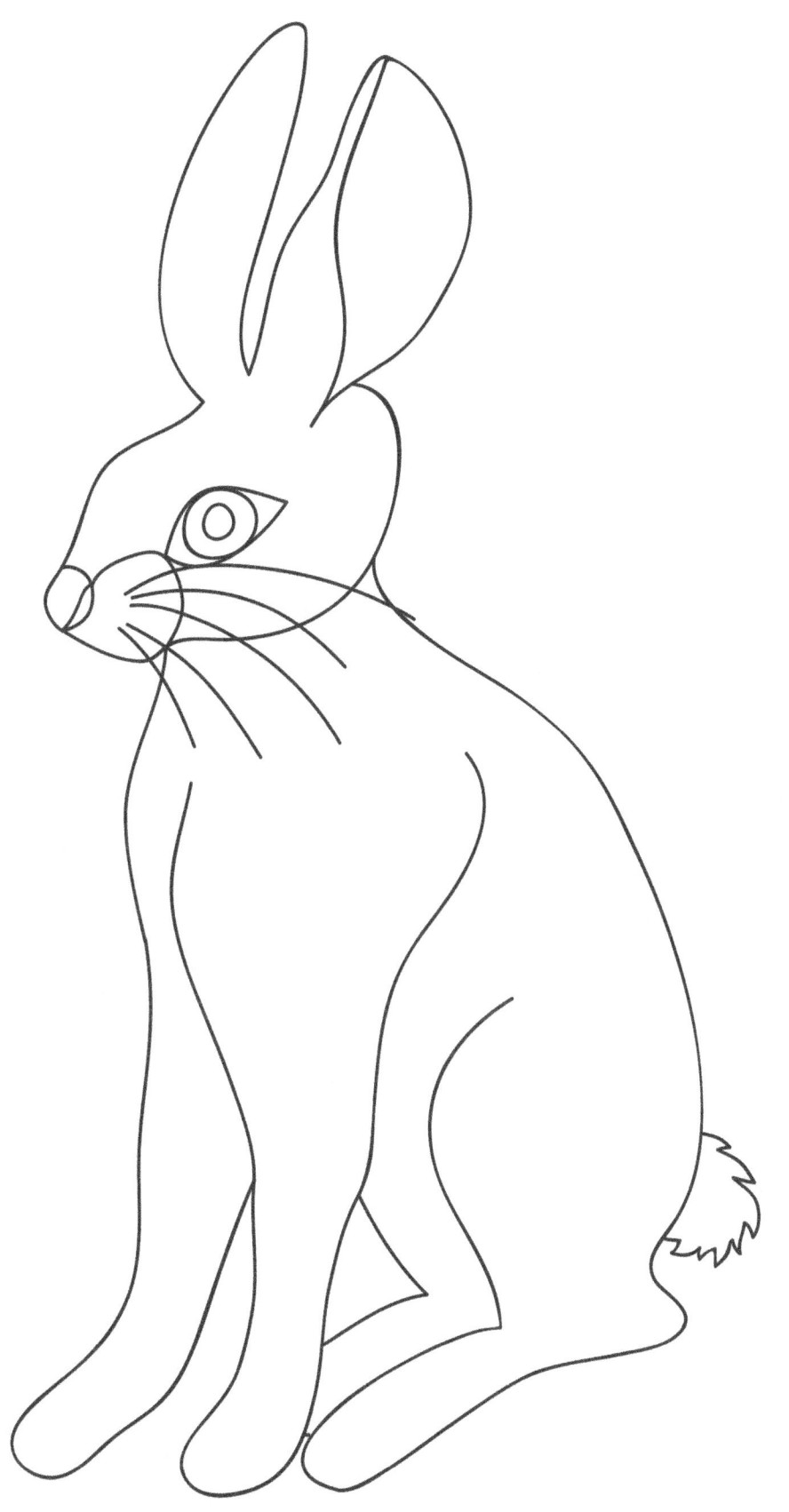

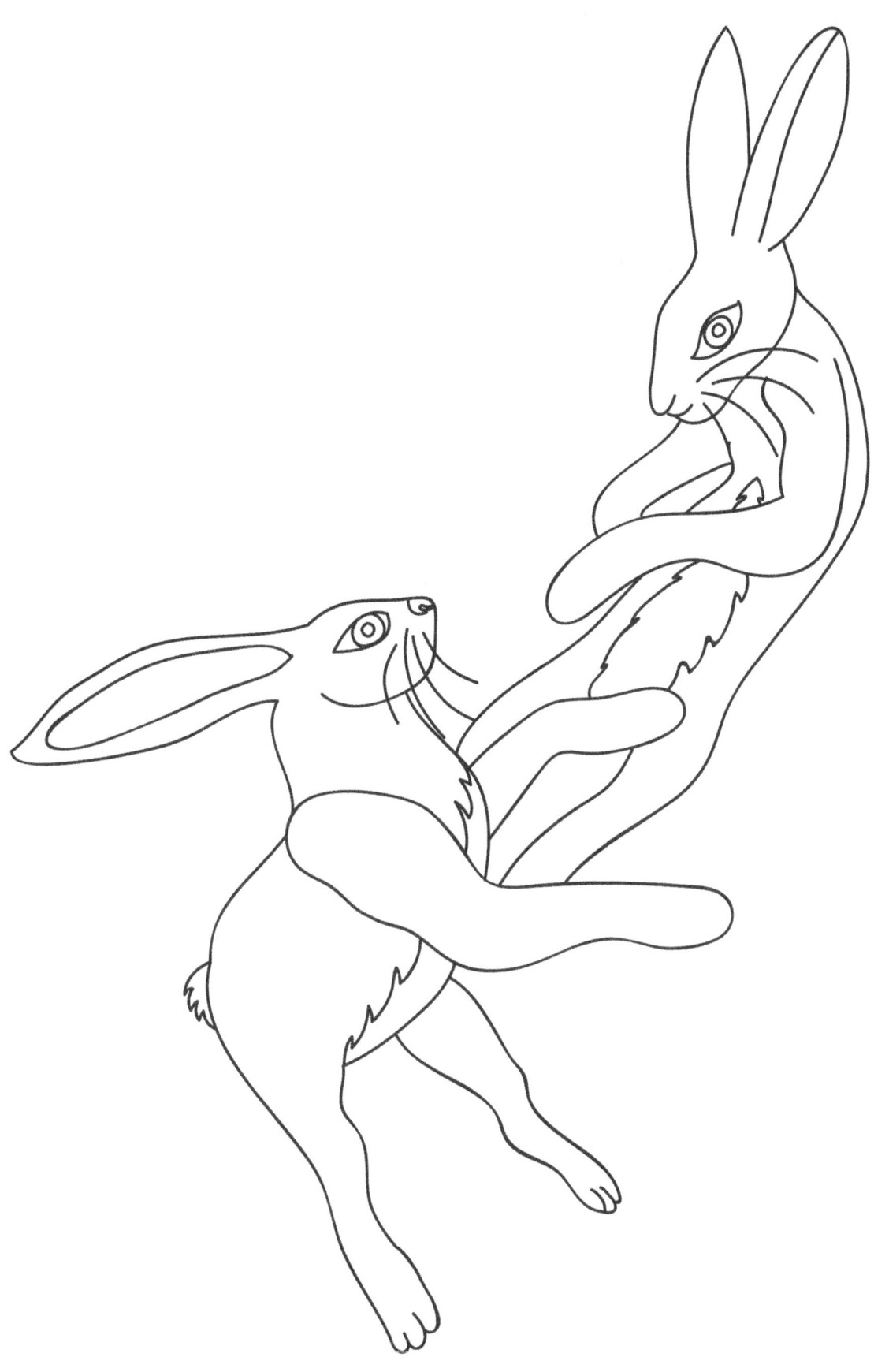

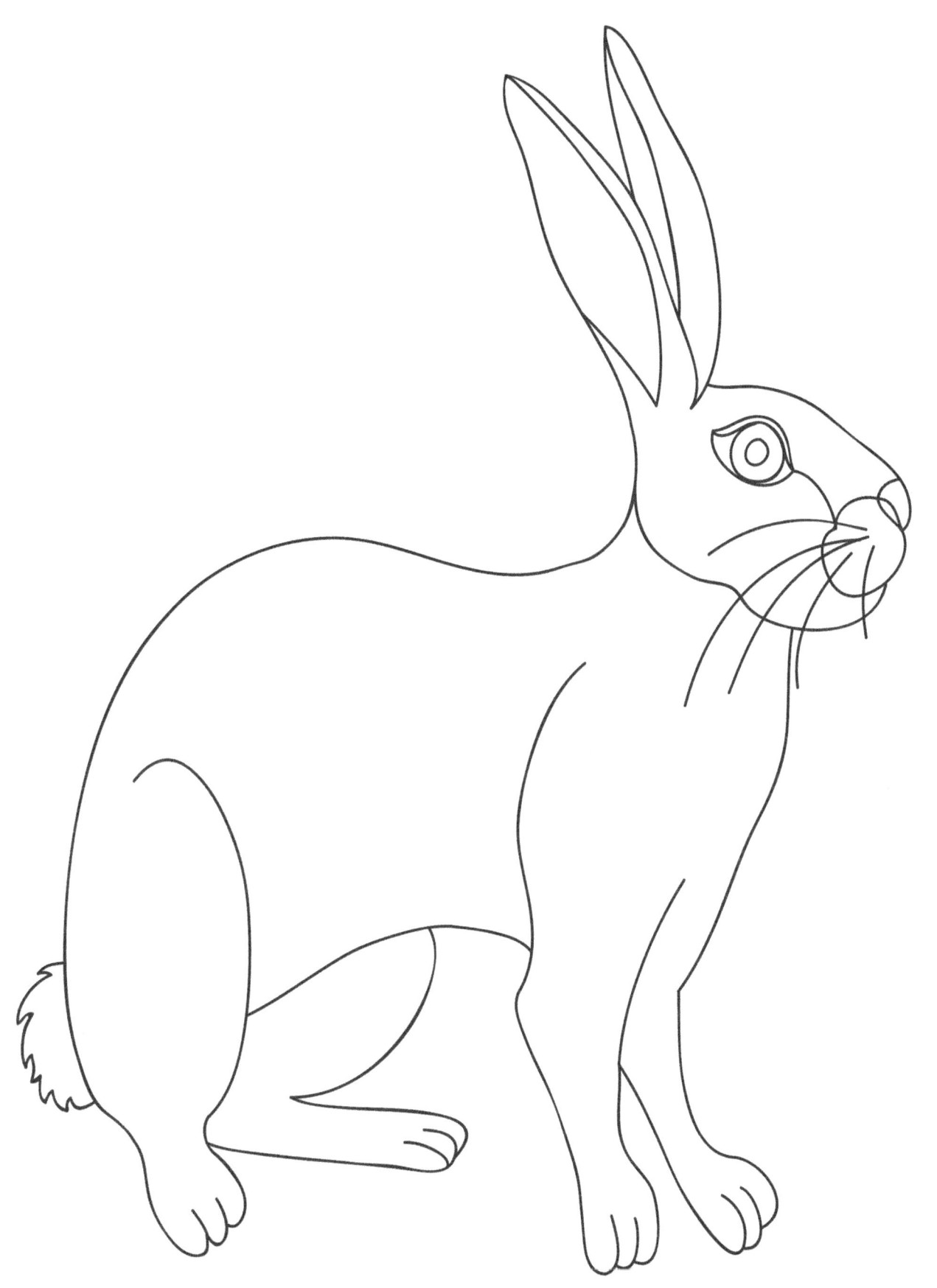

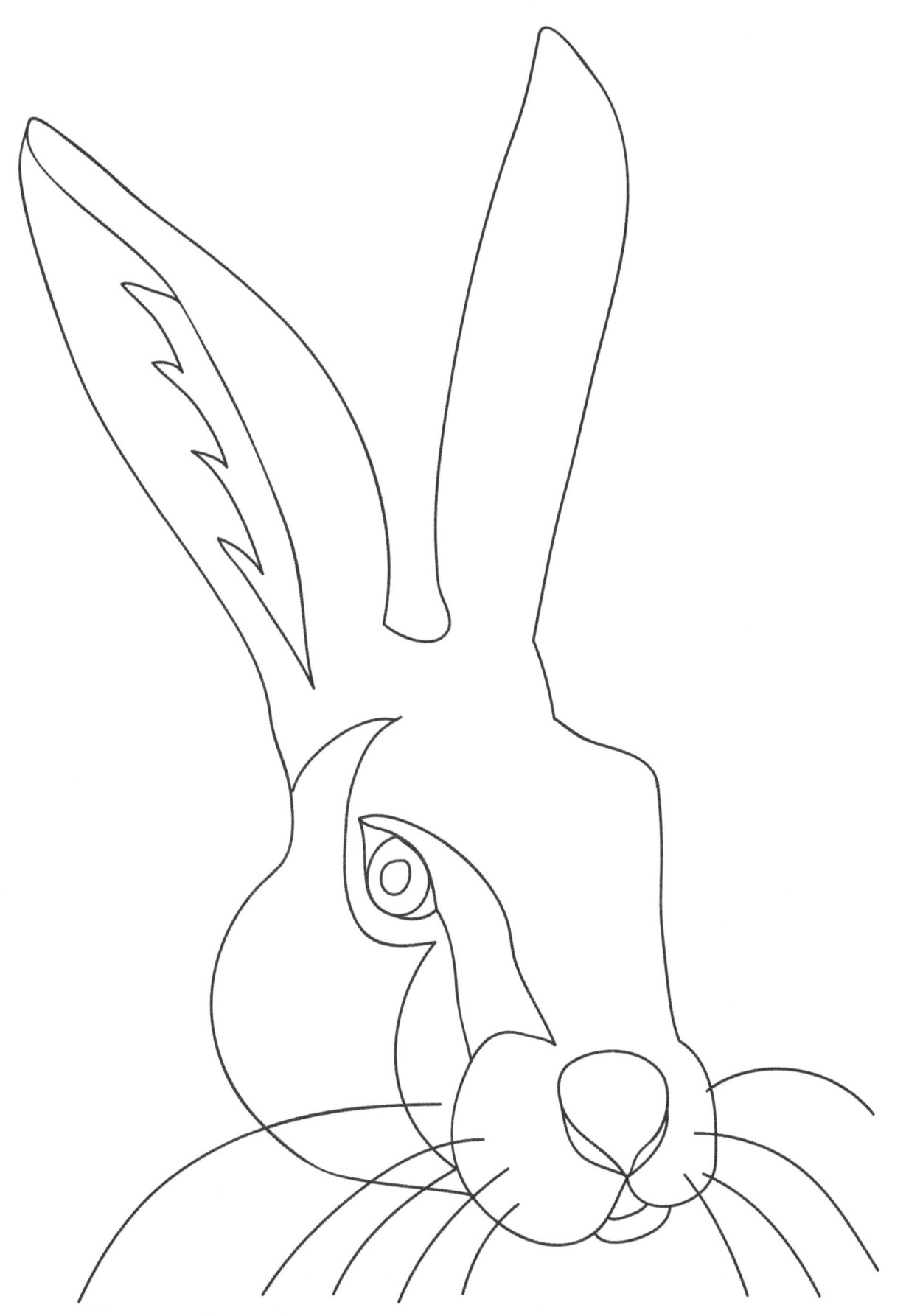

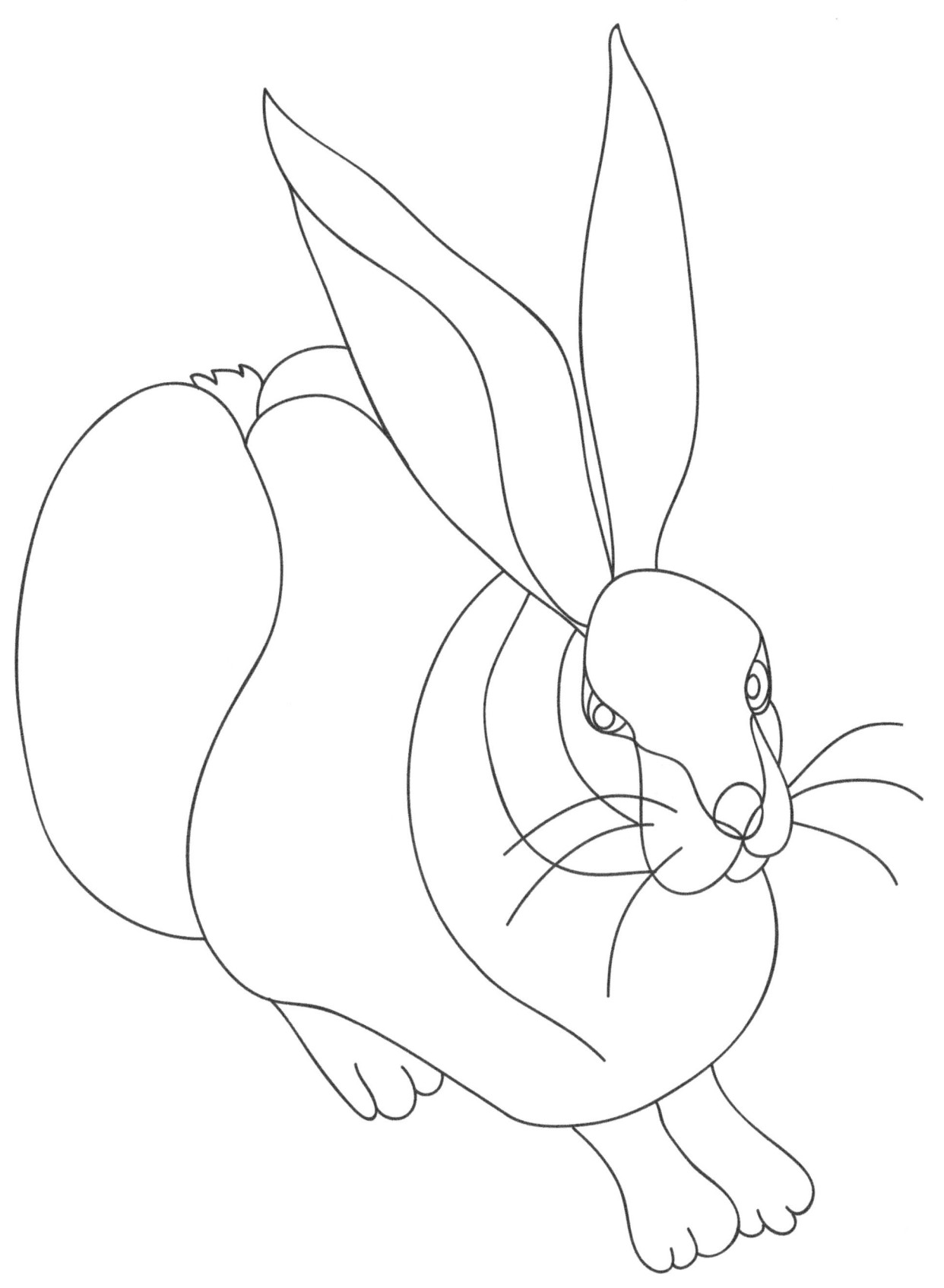

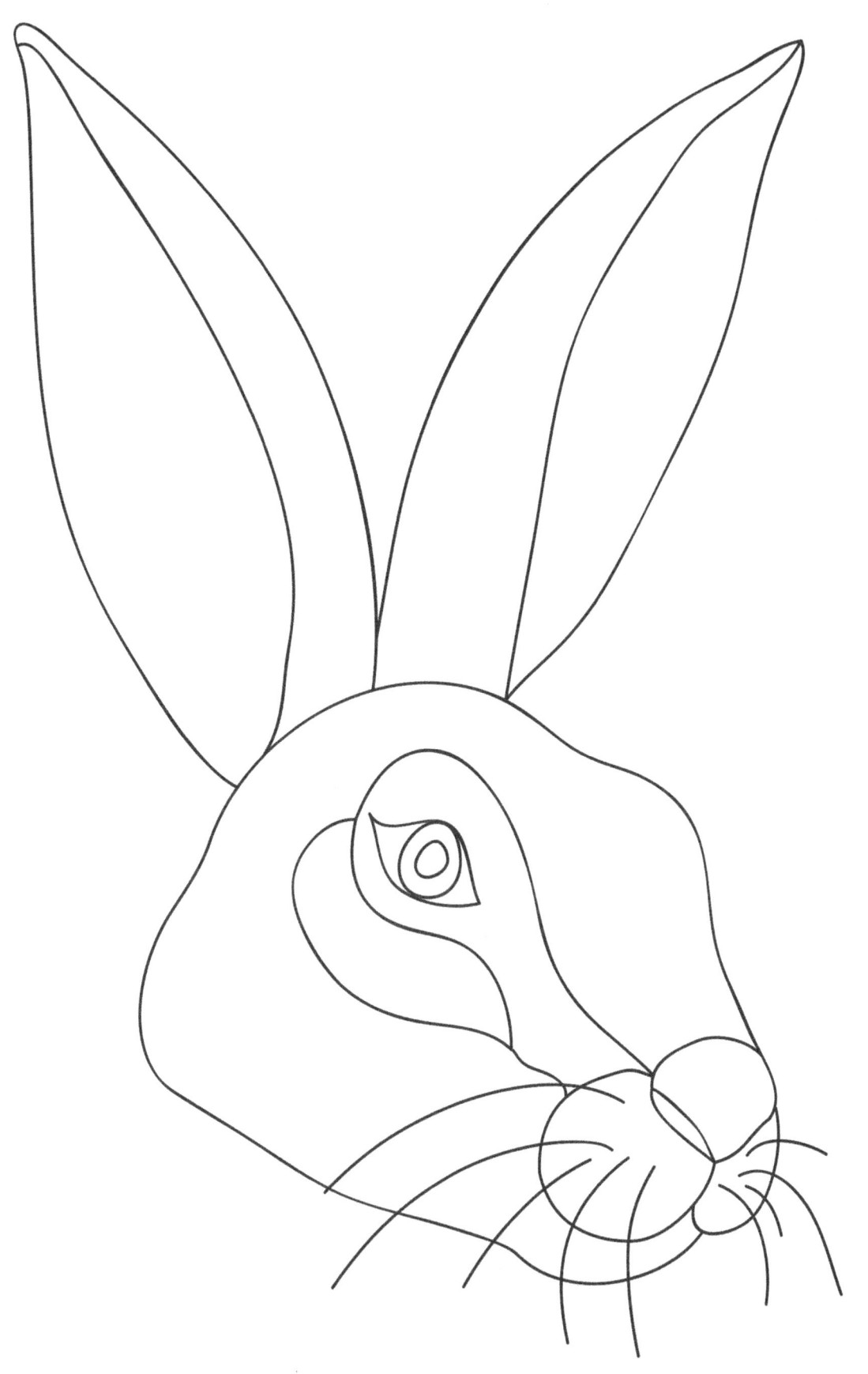

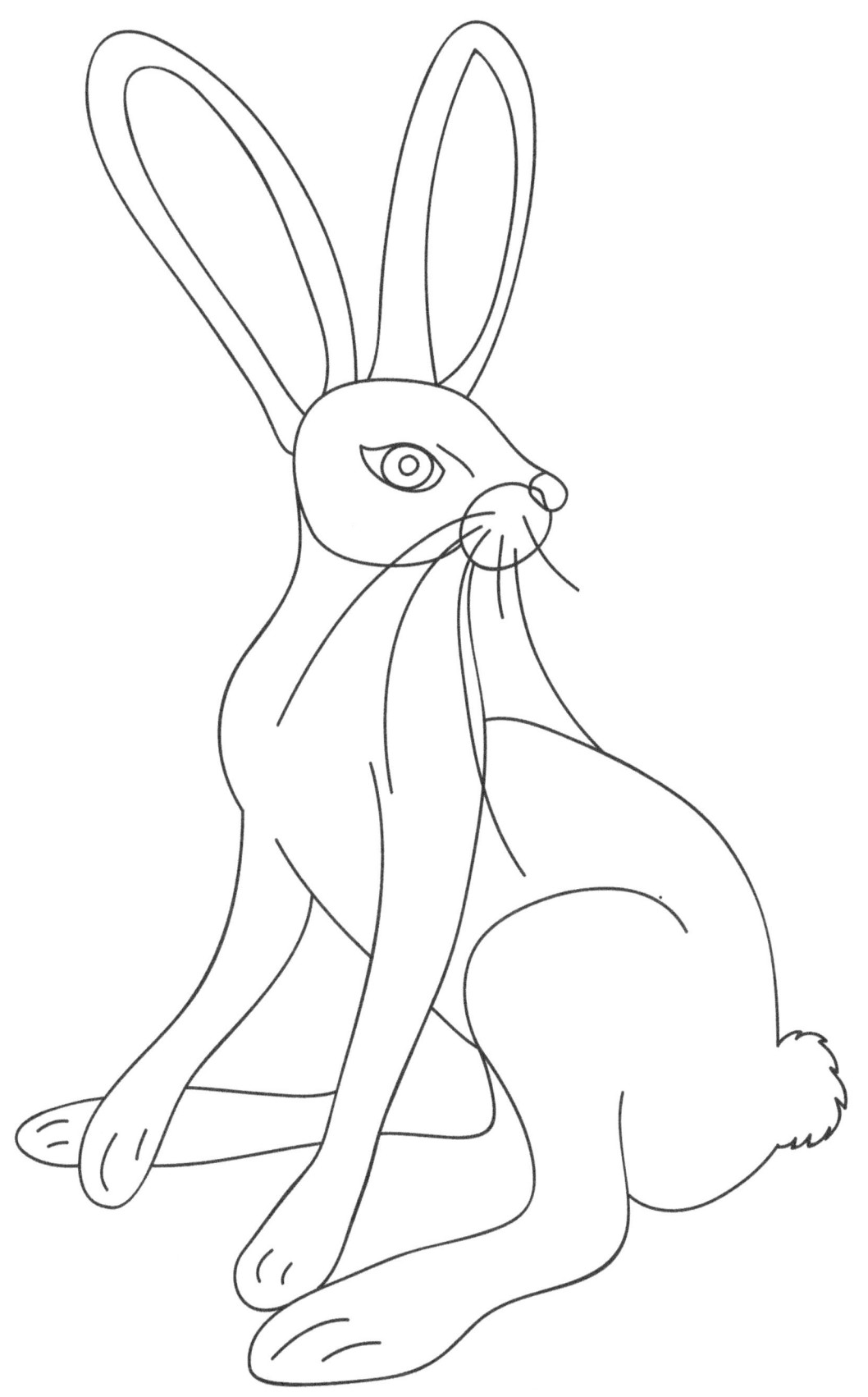

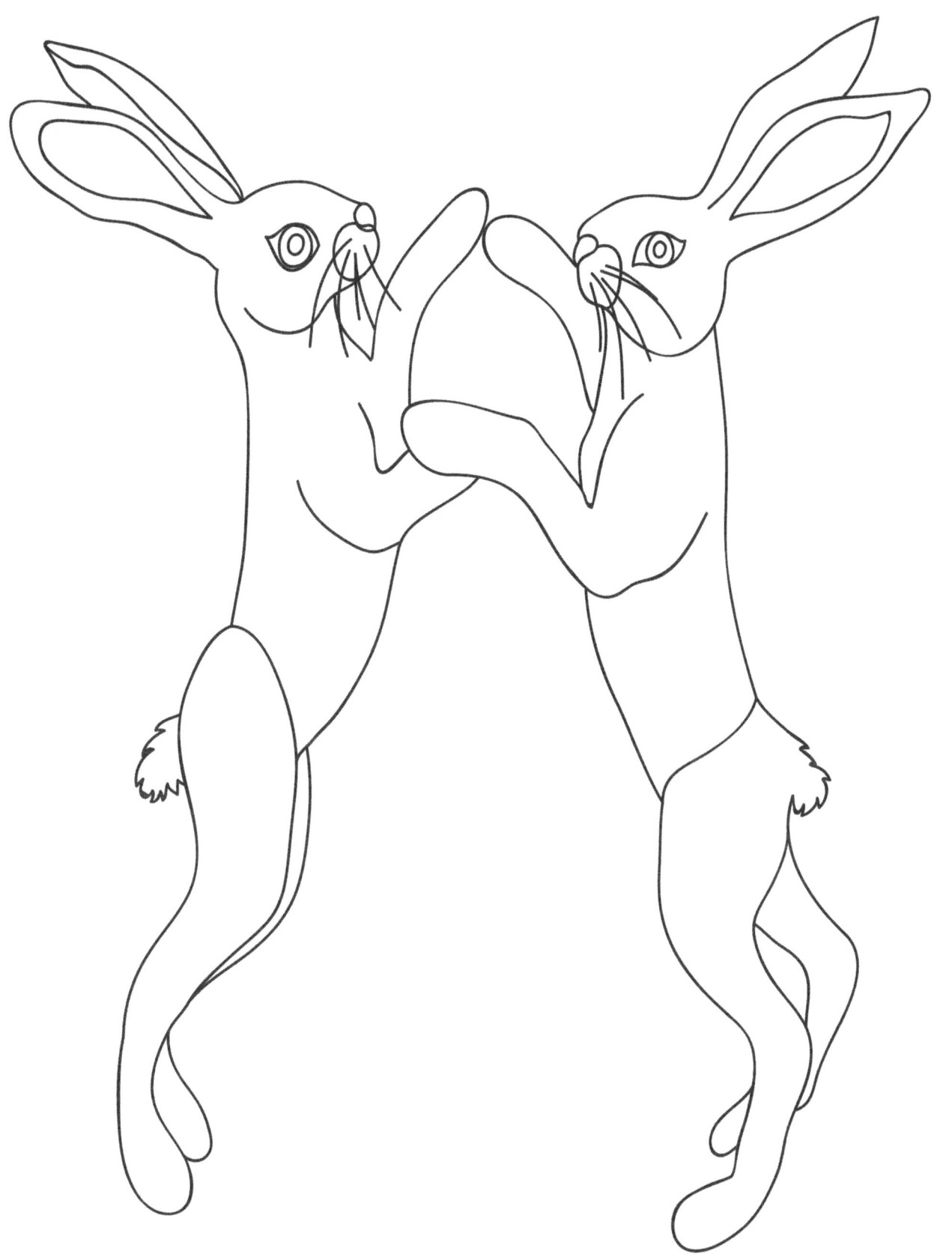

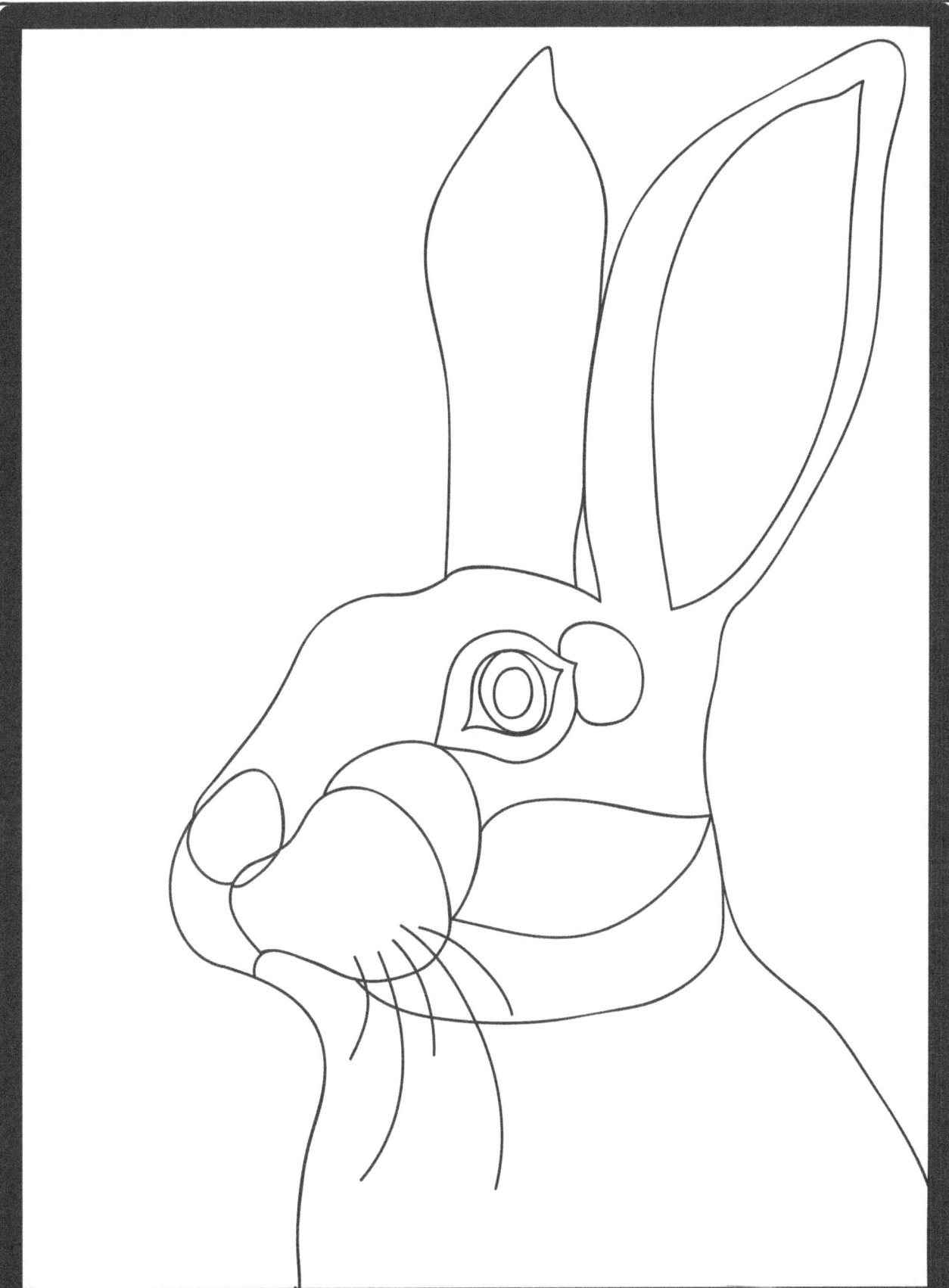

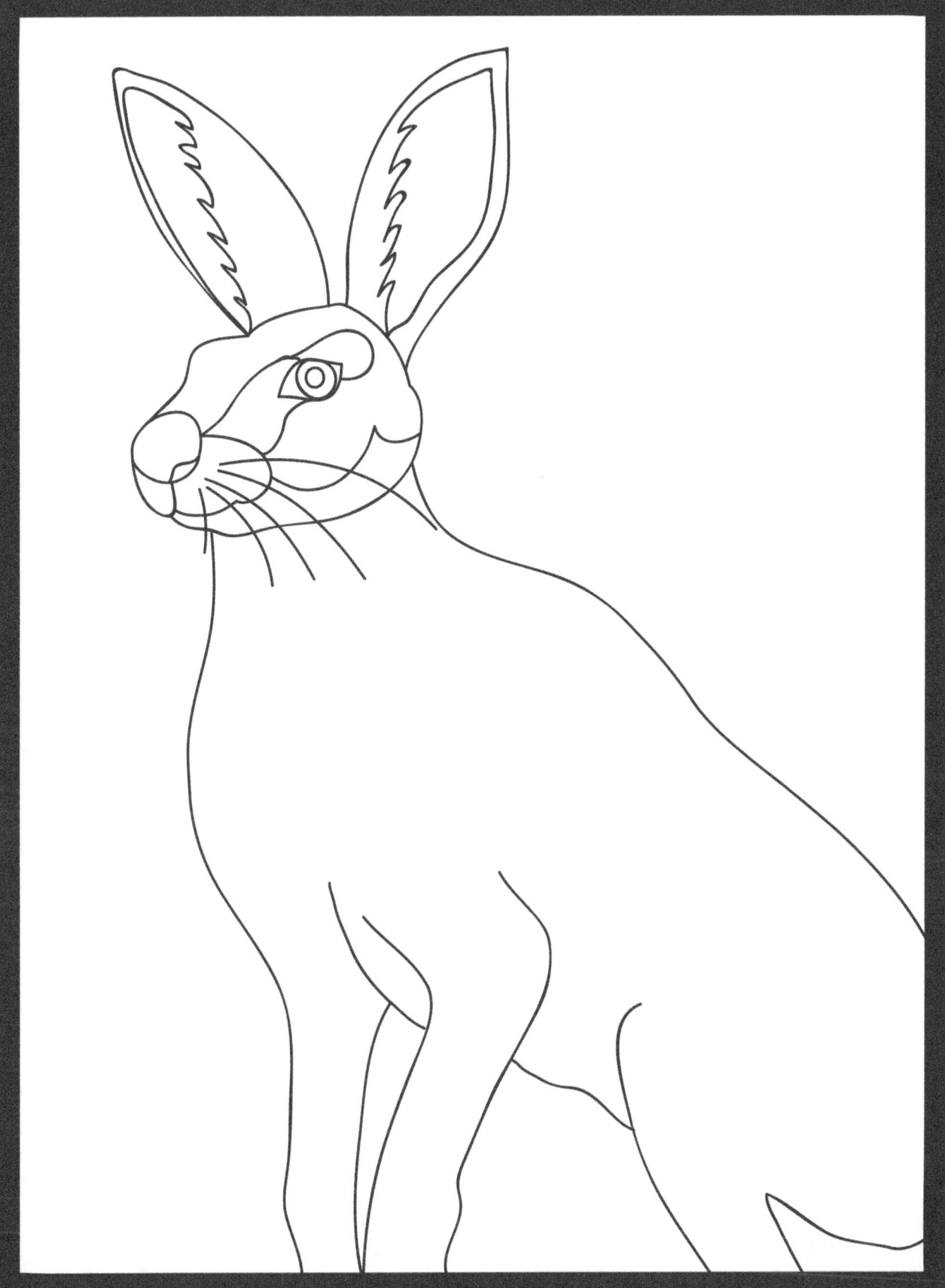

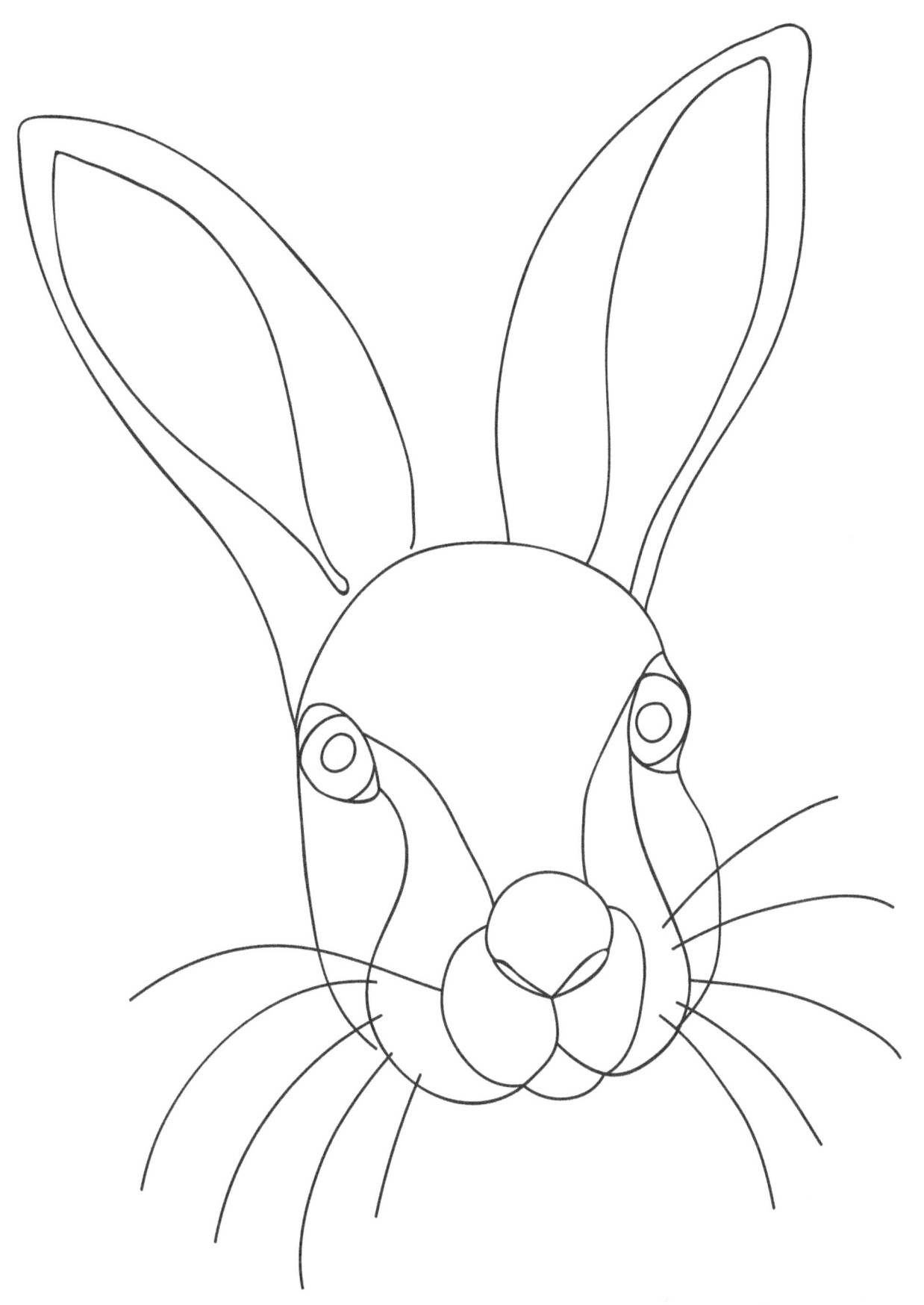

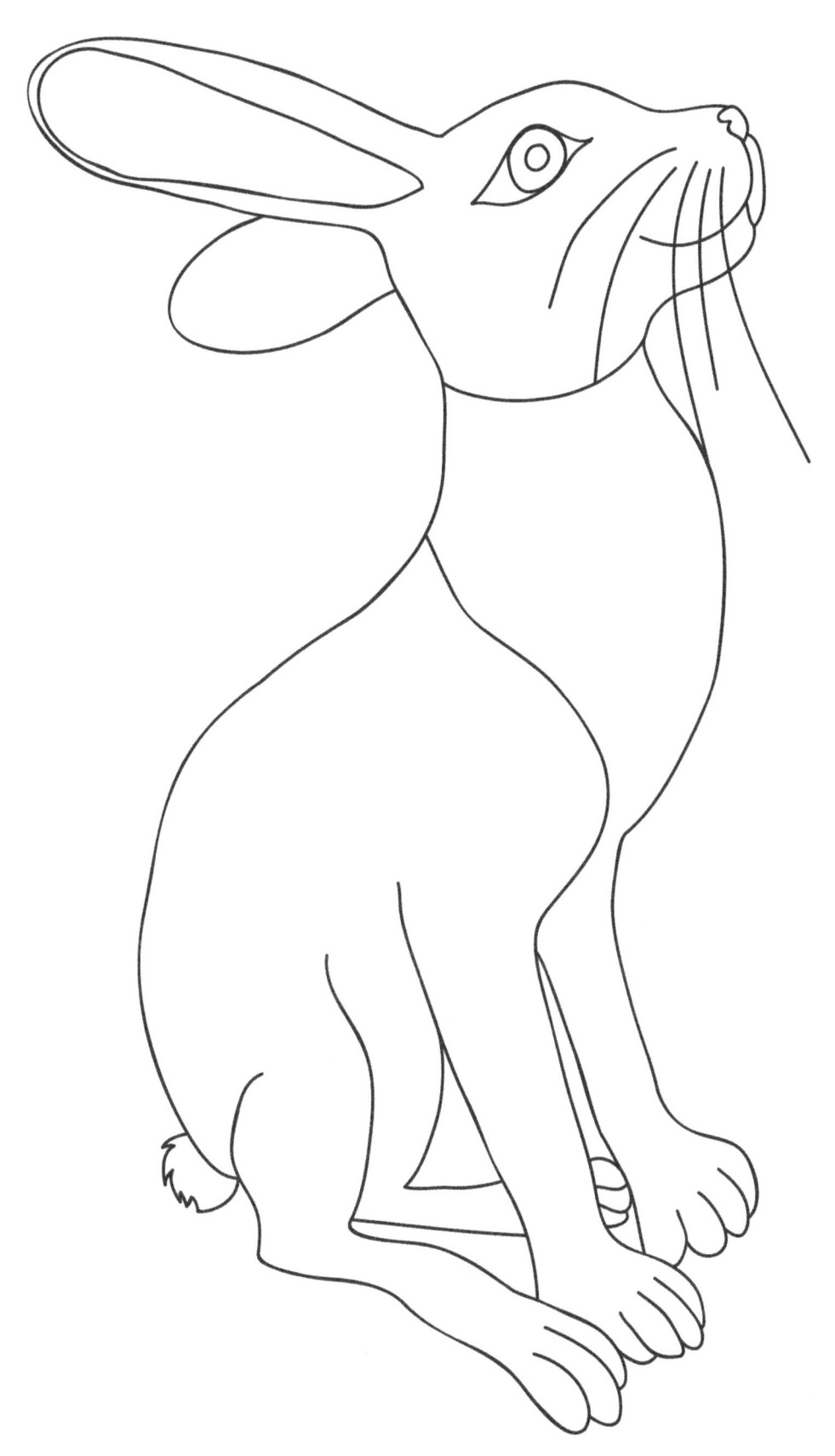

COLOR TEST PAGE

COLOR TEST PAGE

www.ingramcontent.com/pod-product-compliance
Lightning Source LLC
Chambersburg PA
CBHW080621220526
45466CB00010B/3416